ACKNOWLEDGMENTS

I am grateful to Nina Felshin who, with this exhibition, serves as ICI guest curator for the fourth time. As a founding member of ICI's Board of Trustees and a long-standing participant in the ICI Exhibition Committee, she has played a significant role in ICI's eighteen-year history. In *Empty Dress: Clothing as Surrogate in Recent Art* she has once again curated a substantial and provocative exhibition, with an accompanying catalogue essay that illuminates her topic.

The lenders to the exhibition and the artists whose work is included in it have been extremely generous. Without their assistance and participation, *Empty Dress* could not have been organized. Maureen Connor, Elise Siegel, and Judith Shea were especially helpful, and I thank them on behalf of Nina Felshin and ICI's staff.

Invaluable support for the production of this catalogue has been provided through a very generous grant from the Ida and William Rosenthal Foundation, Inc. Their continuing assistance is very much appreciated as is support for the exhibition and tour from the Bernard F. and Alva B. Gimbel Foundation, Inc., the Canadian Government, and ICI's Exhibition Patrons Circle.

ICI's extraordinary staff—Judith Olch Richards, Jack Coyle, Lyn Freeman, Anne Longnecker, Nicole Fritz, and Alyssa Sachar—has once again organized an exceptional exhibition. I commend and wholeheartedly thank each of them for their contributions to its success. ICI's loyal and supportive Board of Trustees deserves continuing accolades as well as my gratitude for their involvement and assistance in all that ICI accomplishes.

Susan Sollins
Executive Director

Empty Dress: Clothing as Surrogate in Recent Art

Nina Felshin

EMPTY DRESS

CLOTHING AS SURROGATE IN RECENT ART

INDEPENDENT CURATORS INCORPORATED · NEW YORK

EMPTY DRESS
Clothing as Surrogate in Recent Art

Nina Felshin, Guest Curator

Essay by Nina Felshin

A traveling exhibition organized and circulated by
INDEPENDENT CURATORS INCORPORATED, NEW YORK

ITINERARY

Neuberger Museum
State University of New York, Purchase
Purchase, New York
October 3, 1993 to January 2, 1994

Virginia Beach Center for the Arts
Virginia Beach, Virginia
January 9 to February 20, 1994

University Gallery
University of North Texas
Denton, Texas
March 1 to April 25, 1994

Mackenzie Art Gallery
Regina, Saskatchewan, Canada
August 19 to October 30, 1994

The Gallery/Stratford
Stratford, Ontario, Canada
April 14 to May 14, 1995

Selby Gallery
Ringling School of Art and Design
Sarasota, Florida
August 14 to September 23, 1995

The catalogue is supported by a grant from the Ida and William Rosenthal Foundation, Inc., and the ICI Exhibition Patrons Circle. The exhibition and its tour are made possible, in part, by grants from the Government of Canada and the Bernard F. and Alva B. Gimbel Foundation, Inc.

LENDERS

Richard Anderson Gallery, New York

Polly Apfelbaum

Josh Baer Gallery, New York

Ruth Bloom Gallery, Santa Monica

Eli Broad Family Foundation

The Edward R. Broida Trust

Sarah Charlesworth

Chase Manhattan Bank, N.A.

Maureen Connor

Paula Cooper Gallery, New York

Galerie Crousel-Robelin, Paris

Nancy Davidson

Lesley Dill

Suzan Etkin

Steven Evans

Leslie Fry

Germans van Eck Gallery, New York

Robert Gober

Jay Gorney Modern Art, New York

Barbara and David Hancock

Oliver Herring

Paul Kasmin Gallery, New York

Michael Klein, Inc., New York

Barbara Kruger

Annette Messager

Eileen and Peter Norton

Nancy and Steven Oliver

Postmasters Gallery, New York

P.P.O.W., New York

Elaine Reichek

Horodner Romley Gallery, New York

Ruth Scheuing

Stephen Schofield

Elise Siegel

Jack Shainman, New York

Judith Shea

Galerie Urbi et Orbi, Paris

Millie Wilson

Christopher Wool

Private collection

You're born naked, and the rest is drag.

—RuPaul, 1993

This new twist on the aphorism 'clothes make the man'—itself a paraphrase of Shakespeare—suggests both the enduring interest in the signifying power of clothing and the contemporary focus of that interest.[1] Historically, clothing has been a familiar presence in figurative art; as an accompaniment to the human body it has functioned formally, iconographically, and as a signifier of class and social status. Even in our own century, with its long exploration of abstraction, fashion and costume design have played a role in such movements as Futurism, Constructivism, and Surrealism. Now, however, we are seeing a departure from the traditional use of clothing as an accoutrement for the body. Instead, artists today represent clothing as *abstracted* from the body, in order to investigate issues of identity. It is this current phenomenon, in which the body is entirely absent, that is the subject of *Empty Dress*.

Clothing is where our interior selves meet the world. Not only does it offer us protection, both physical and psychological, but it is a system of signification that communicates messages about our identity. Elise Siegel, one of the artists in *Empty Dress*, writes "Clothing is about who we think we are and how we choose to represent ourselves. It is about how we are seen and culturally defined."[2] It is, then, a richly coded site for an examination of psychological, sexual, and cultural identity.

Much has been written over the past decade about the role of clothing in the construction (and deconstruction) of identity. Because clothing is more often than not gender-specific, recent literature has primarily addressed the way clothing molds and expresses gender and sexuality. Often, it has challenged notions of fixed or biologically determined gender boundaries. Artists who

abstract clothing from the human body both parallel this inquiry and provoke new questions. What is the significance of the absent body? How does its absence alter the garment's meaning? And why is this phenomenon so topical in art right now?

Since the mid- to late 1970s, ideas about sexuality and sexual difference have been central to the feminist critique of representation in the visual arts. As Laura Mulvey wrote in 1975, "In a world ordered by sexual imbalance, pleasure in looking has been split between active/male and passive/female. The determining male gaze projects its fantasy onto the female figure, which is styled accordingly."[3] This classic statement on gendered looking describes an unequal power relation in which some viewers have the power (and some do not) to determine the images that shape identity.

To the respective halves of Mulvey's "active/male," "passive/female" dichotomy could be added the terms "presence" and "absence." The patriarchal positioning of women has led to their absence from history, and has denied them control over the images that represent them. In *After Muybridge* (1991) and *After Man Ray* (1992), Kathy Grove addresses this historical exclusion of women as it has played out in art history. Both works are from Grove's *Other Series*, in which she appropriates famous images from art history, usually by male artists, and seamlessly removes the female subject. The empty dress is then all that remains of the appropriated images. Grove writes "What has been left out becomes as important as what is included." Her intention in these works is to "imitate historical engineering with its deletions, deceptions, and reconstructions."

Elaine Reichek's *Grey Man* (1989), is unique in the exhibition in that it represents a fusion of sexual and cultural difference. It is from a series of works in which Reichek displays two kinds of images side by side: early 20th-century ethnographic photographs of the Indians of Tierra del Fuego, and handknitted effigies, made by the artist, of the men these photographs depict. By juxtaposing the photographs with the handmade surrogates Reichek offers a critique of prevailing representations of non-Western cultures. The photographs the artist presents in this series, originally taken by white male photographers, are all that remain of this culture. The demise of the island's indigenous residents was brought about by the arrival of Europeans at Tierra del Fuego. *Grey Man* is unique in *Empty Dress* in another sense as well: properly speaking, it does not deal with clothing at all, since the Tierra del Fuego Indians went naked but for body paint. By hand-

knitting and replicating the shape of the Indian's body with its painted patterns, Reichek creates a kind of union suit. She uses the knitted medium to address the "other" status of women in the history of representaion. As Reichek puts it, this work is "about presence and absence, who has a voice and who does not."[4]

In recent years, male and female visual artists from a variety of culturally marginalized groups have expanded on the feminist critique of representation. For example, many gay men and lesbians feel that their self-image has been imposed on them, and they have adapted the feminist critique to their own concerns. Like heterosexual women, they have occupied a disadvantaged position in the politics of difference. This has always been the case in modern culture, but the 13-year-old AIDS crisis has made the situation painfully clear. It has also inspired many gay and lesbian visual artists to challenge media-generated representations of homosexuality by constructing self-defining images of their own.

Of the eight lesbian and gay artists in *Empty Dress*, seven explore gender boundaries. Stephen Schofield, for example, conflates male and female genitalia in *The Envelope Please* (1990) and *Hung Pockets* (1990)—rubber glove "ensembles" in which, by "turning inside out, doubling, involuting the gloves to draw the phallus form through various avatars to emerge in the complementary forms of vagina, labia, or anus," Schofield underscores the fluidity of the boundaries of sexual identity. Gotscho's *Wedding* (1992) works similarly: composed of a readymade wedding dress and a man's black suit, the front of one is handsewn to the front of the other. The garments join, leaving no opening that would allow them to be worn. Gotscho refers to the area where the two garments flow together as the "transit zone."

The frilly, "feminine" blouses in Steven Evans's tableaux, *The Turn of the Screw* (1990–92) and *Evidence of a Subliminal World* (1992), were made as boys' wear at the turn of the century and evoke the androgynous sexuality of prepubescence. Like Evans, Oliver Herring uses ambiguously gendered or "genderless" garments. His handknitted Mylar coats from the series *A Flower for Ethyl Eichelberger* (1992–93) undermine the oppressive stereotypes of traditional gender roles, just as the late Ethyl Eichelberger did in his performances in drag. Robert Gober and Christopher Wool cross similar boundaries of gender roles in their collaborative photograph of a dress hanging from a tree in the woods. Gober sewed the dress by hand; Wool painted its print pattern.

Most of the work in this group challenges the absolute binary division of gender into female and male by fusing aspects of each within clothing. In cross-dressing, which also may be viewed as a sign for unstable identity, there is a disjunction between clothes and the body. In *Trousers (for Tony)* (1992), the only work in the show that directly addresses cross-dressing, Millie Wilson avoids visual representation altogether, depicting neither body nor clothes. Instead, Wilson addresses the shifting nature of identity exclusively through language, producing what she refers to as a "problematized intersection of class, gender, and sexuality, a 'she' who resists the feminine fashion commodity by reinventing herself as a thrift-store dandy." *Trousers (for Tony)* consists of two engraved brass plaques mounted on a field of brilliant blue painted on the wall. A narrative text is engraved on one, a list of euphemisms for trousers on the other. The work's visual format echoes the aesthetic and formal strategy often employed by Wilson's artist friend, Tony Greene, who died of AIDS and to whom it is dedicated.

Questioning gender boundaries is not the exclusive preserve of gay and lesbian artitsts in *Empty Dress*. Leslie Fry's smaller-than-life chiffon wall sculptures, *Fit* (1992) and *Imago* (1992)—"clothing for imaginary beings" —suggest a hermaphroditic "psychological melding of male and female sexuality." Like Schofield's rubber gloves, they refer to female and male genitalia alike.[5] Polly Apfelbaum's melancholy empty clown costumes underscore sexual ambivalence in two ways: typically unisex in design, their characteristic bagginess also disguises the wearer's gender.

The use of empty clothes by gay male artists may be viewed as a way to solve the problem of representation. However, in the context of the AIDS crisis empty clothes must also be seen as a literalization of loss or a memento mori, a reminder of death. AIDS has had such a devastating effect on the art world that it seems unlikely that anyone in that world has totally escaped its impact, least of all gay men. Literalized as absence, the shadow of AIDS not only hovers over the work of the gay artists in the exhibition but over the entire show. Although Wilson's *Trousers (for Tony)* is the only work in the exhibition that refers explicitly to AIDS, a number of other works allude to it. The "memento mori effect" that Steven Evans comments on in relation to his blouses is also evoked by Gotscho's empty mens' suit jackets with their linings hanging out, by Claude Simard's closet full of male clothing, and by Herring's floor-bound coats that are dedicated to a performance artist who committed suicide after being diagnosed with AIDS. The reference to condoms in works by Fry and Schofield, as well as the latter's use of rubber gloves, also allude to AIDS.

This recent proliferation of an art of empty clothing should not obscure its precedents in the mid-'70s and early '80s. Mary Kelly must be credited as one of the first to use empty clothing to explore absence as a strategy of resistance: "The (neo-)feminist alternative," she wrote, "has been to refuse the literal figuration of the woman's body, creating significance out of its absence."[6]

This exhibition presents one part of Kelly's *Corpus* (1984–85), itself the first of a four-part project, *Interim* (1984–89). For Laura Mulvey, *Corpus* concerns "the crisis of the female body at a certain age and the crisis of representation caused by feminist resistance to images of the female body."[7] Its thirty panels are divided into five groups, each named after one of the *attitudes passionelles* (*Menacé*, *Appel*, *Supplication*, *Erotisme*, and *Exstase*) identified by the 19th-century French neuropathologist J. M. Charcot as the poses of female hysterics. Each group consists of three diptychs, each diptych of one text and one image panel. The texts, culled by the artist from hundreds of conversations with women, refer to the discourses of fashion, popular medicine, and romantic fiction, and underscore the exclusion of middle-aged women from dominant representations of the female subject. Paired with the text panels are photographs of clothing, a different article for each group and a different arrangement for each panel: a black leather jacket (*Menacé*); a handbag (*Appel*); a pair of shoes (*Supplication*); a sheer black nightgown (*Erotisme*); and a white summer dress (*Extase*)[8] Kelly's use of clothing as a substitute for the human body "immediately announces that it is not the biological body which is in question. Rather, it is the body image, the imaginary body, the body as a construction in discourse."[9]

By combining text with images of empty clothing, *Corpus* represents an important bridge between the language-based, neo-feminist critical artwork of the late '70s and early '80s, which addressed representation and sexual difference, and the more recent work in *Empty Dress*, in which formal qualities dominate and language is all but absent.[10] If *Corpus* offers a theoretical precedent for much of the work in *Empty Dress*, then the early work of Judith Shea along with that of Maureen Connor can be regarded as a formal precedent.[11]

There were three important influences for Shea and Connor in the mid- to the late 1970s: the early phase of feminism, pattern painting, and the clothing-dominated aspect of '70s performance art.[12] Their early work reflects some of the formal (as opposed to the ideological) aspects of the feminism of that period, including the revival of the use of traditionally female materials (fabric), methods (sewing), and forms (clothing). Many of Shea's cloth works from 1975 until

around 1981 consist of handsewn, relatively flat, garmentlike pieces, frequently in sheer fabrics. These simple shapes refer ironically to the male-identified cerebral aesthetic of Minimalism, which dominated Shea's formative years as an artist.[13] Connor's clothing works of 1977–79, such as *Little Lambs Eat Ivy* (1977), include assemblages of readymade garments pinned to the wall. Both artists were interested in injecting a feminist sensibility into a formalist vocabulary.

Sarah Charlesworth's work of the early '80s represents a synthesis of the theoretical and formal impulses underlying *Empty Dress*. Among the works in her 1983–88 series, *Objects of Desire*, are re-photographed advertising, fashion, film, and pornographic images of clothing, empty and isolated on black or red grounds. By removing the head and limbs from the photographs, even though the garments retain the molded form of the absent wearer, Charlesworth erases the identity of the wearer. *Figure* (1983) depicts the slinky satin evening gown worn by Marlene Dietrich in the 1936 film, *Desire*. Other images include a wet-T-shirted male torso with a hard-on, a wedding gown, and a sheer red scarf. By emptying the clothes of a specific individual, Charlesworth questions the "codes by which we as a culture articulate desire—sexual, material and aesthetic." At the same time, she observes, the absent body allows us to "measure ourselves in a way, to see if the shoe fits."[14]

While *Objects of Desire* examines the formal or structural properties by which meaning is created—"the shape of an idea," as Charlesworth puts it—*Figure* depicts the shape of feminine desire. Several other artists, including Maureen Connor, Nancy Davidson, and Suzan Etkin also explore the outward trappings—the masquerade—of desire through formal language, whose vocabulary includes tightly stretched, layered, or gently draped transparent, translucent, or netted fabrics in the colors and textures of seduction.

A concern with formal attributes is not limited to these artists. Clues to the meaning of other works in the show can be found in the artists' selections of materials (rubber, sheer fabric, felt, and metal, among others), method of construction (knitted, sewed, sutured, unwoven), use of color, scale, and the number and relationships of their parts. An examination of structural characteristics—whether an object is supple or rigid, open or closed, mobile or stationary, folded or draped, stretched taut or layered, arranged on the floor or serially on the wall—also yields meaning.

Unlike much recent art that addresses political and cultural issues, the work in this exhibition resists single readings and is unafraid to seduce the viewer with offers of visual pleasure and poetry.

Absence and presence are on equal footing in *Empty Dress*. The empty garment is analogous to Roland Barthes's authorless text, and the viewer to his reader. Like the authorless text, the figure's absence creates a space for the viewer. "The text," according to Barthes, "is not a line of words releasing a single...meaning...but a multidimensional space in which a variety of writings, none of them original, blend and clash. The text is a tissue of quotations drawn from the innumerable centers of culture."[15]

The common thread in *Empty Dress* is the role clothing plays in the construction of identity. Removal of the body calls attention to the artifice of clothes and makes their implicit codes more accessible to interpretation. The body's absence also demands that we read between the lines, examining the meaning of what is not represented—examining the conditions of representation itself. The fabric of each work is woven of many threads. "Everything is to be *disentangled*, nothing *deciphered*."[16]

Notes

1 RuPaul is a drag queen who has achieved superstar status as a songwriter and vocalist in the world of popular culture. According to the *New York Times*, he "transforms pop's sex-as-subtext underpinnings into a forum for personal politics." (David A. Keeps, "How RuPaul Ups the Ante for Drag," *New York Times*, 11 July 1993.) 'Clothes make the man' is a paraphrase of the words spoken by Polonius in *Hamlet*, Act I, Scene III: "For the apparel oft proclaims the man."

2 Elise Siegel, artist's statement. Unless otherwise indicated, all quotations of the artists in the exhibition are from their written statements.

3 Laura Mulvey, "Visual Pleasure and Narrative Cinema," *Screen*, no. 3 (Autumn 1975), pp. 6–18.

4 Elaine Reichek, in conversation with the author, 22 July 1992.

5 Fry's *Fit* and both of Schofield's works also refer to condoms. Evoking the condom is important, says Schofield, because "it is crucial that we create images that incite desire and eroticize that almost impalpable membrane."

6 Mary Kelly, "Desiring Images/Imaging Desire," *Wedge*, no. 6 (Winter 1984), p. 7.

7 Laura Mulvey, "Impending Time," in the exhibition catalogue, *Mary Kelly: Interim* (Edinburgh: Fruitmarket Gallery, 1986), p. 4. *Menacé*, the first section of *Corpus*, was shown for the first time in the United States at the New Museum, New York, in the traveling exhibition, *Difference: On Representation and Sexuality*, 8 December 1984–10 February 1985. This exhibition introduced New York viewers to British and American artists whose language-based, text-and-image works of the late 1970s and early 1980s addressed the relationship between representation and sexual difference. *Interim* was also shown in its entirety in early 1990 at the New Museum. Kelly is a teacher as well as an artist, and her theoretical writings from the late 1970s to the present have been influential among feminists and cultural critics. Her famous early work, *Post-Partum Document* (1973–79), which addresses the mother-child relationship, was published as a book by Routledge & Kegan Paul, London, in 1983.

8 For a more detailed discussion of *Corpus* see Mulvey, "Impending Time;" Margaret Iversen, "Fashioning Identity," *Art International*, no. 2 (Spring 1988), pp. 52–57; and Marcia Tucker, Norman Bryson, Griselda Pollock, et al., *Mary Kelly: Interim* (New York: New Museum, 1990).

9 Iversen, p. 54.

10 Of the more recent works, only Lesley Dill's and Millie Wilson's incorporate written language, and Tony Oursler and Constance DeJong employ spoken, descriptive language in their videotape. Dill uses words—the poems of Emily Dickinson—formally and metaphorically as "an intervening armor between ourselves and the world." In *Odd Glove* (1990), Wilson uses words to create poetic ambiguity. In *Trousers (for Tony)* she employs evocative narrative language without any images of clothing or of the body, since they "would have reified a set of readings at the expense of other possibilities."

11 Although the phenomenon documented in *Empty Dress* has been highly visible in the early 1990s, its formal and, to a less theorized extent, conceptual precedents are to be found in the work of a handful of artists of the mid- to the late 1970s. In addition to Judith Shea and Maureen Connor, other artists from this early period include Miriam Schapiro, Mira Schor, Barry Le Doux, and Mimi Smith, whose protofeminist *Steel Wool Peignoir* was executed as early as 1966. Joseph Beuys occupies a unique position in this exhibition by virtue of the early date of his *Felt Suit* (1970). An even earlier empty clothing piece by Beuys is his *Untitled* (1963), a replica of the emblematic felt hat that he always wore. Other isolated examples of empty dress can be found in earlier art—Marcel Duchamp's *Nine Malic Molds*, for example, which form the *Cimitières des uniformes et livrées* in the lower half of *The Large Glass* (1915–23) (brought to my attention by Susan Fillin-Yeh); paintings by Magritte; Jim Dine's paintings of his bathrobes and his less well known *Green Suit* (1959); and the clothing objects in Claes Oldenburg's *The Store* (1961).

12 Performance art of the 1970s in which clothing played a central role included Robert Kushner's various "lines," which hilariously satirized fashion shows; the visual puns made and worn by Pat Oleszko; Jeff Way's layered robes, which he removed like so many identities; and Theodora Skipitares' dresses (one made of 3,000 walnut shells, another of glass), which referred to her Greek-American background. Also worth mentioning is Stephen Varble, who for a few years in the mid- to late 1970s appeared on West Broadway every Saturday afternoon wearing extraordinary drag regalia. Intended to be worn, the costumes of these performance artists were occasionally exhibited. Both Shea and Connor created performance works in the mid-1970s in which clothing dominated. Shea's single venture involved the layering of transparent garments on a female dancer. She regarded this "living color study" as a strictly formal exercise, "like mixing paint" (conversation with the artist, 23 March 1993). One of several performance works produced by Connor in 1977 involved a kind of striptease—the removal of 25 pairs of underpants worn under a Victorian dress. For her, layering was not simply a formal device but a humorous reference to the representation of female sexuality. Beuys wore his *Felt Suit* in *Isolation Unit*, a collaborative "anti-Vietnam war action" performed with Terry Fox in Düsseldorf in 1971.

13 Throughout the 14-year period in which Shea employed empty clothing forms exclusively, formal issues continued to be her primary concern. In the early 1980s she taught a course entitled "History and the Construction of Clothing."

14 Sarah Charlesworth, interviewed by Paul Bob, *East Village Eye* (June 1984), p. 15.

15 Roland Barthes, "The Death of the Author," *Image-Music-Text* (New York: Hill and Wang, 1977), p.146.

16 Ibid., p. 147.

PLATES

POLLY APFELBAUM

Two Spanish Ladies Under a Gypsy Moon, 1990
2 felt hats on 2 metal chairs with vinyl seats
35 × 15 × 17 inches each

I'm not sure if the clothing functions in my work as a
surrogate for the body; I think instead it is an
attempt to make a narrative without an explicit sub-
ject: the hats, dresses, or suits are the clues which
point to something else, something which has
already happened, or is about to happen, but since it
is not present remains abstract and uncertain.

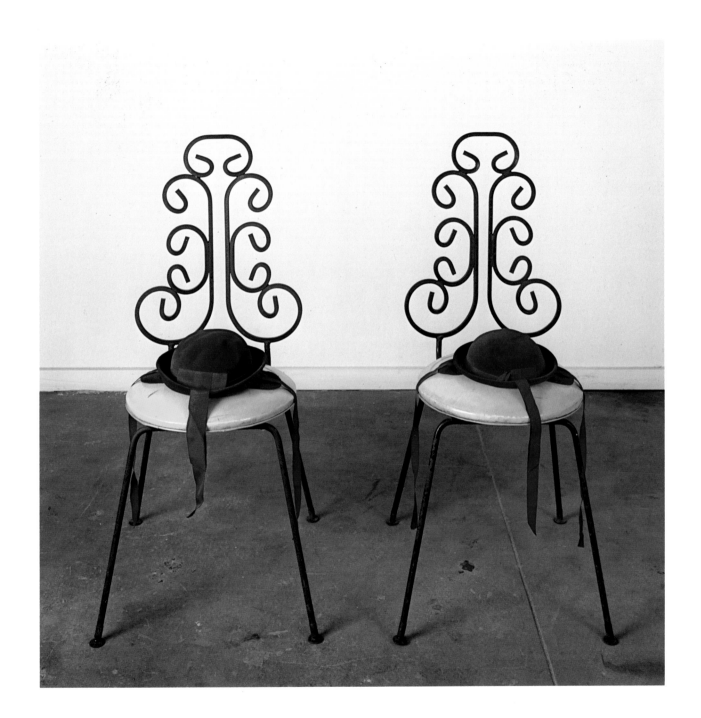

JOSEPH BEUYS

Felt Suit, 1970

Felt with wooden hanger

72 × 28 inches

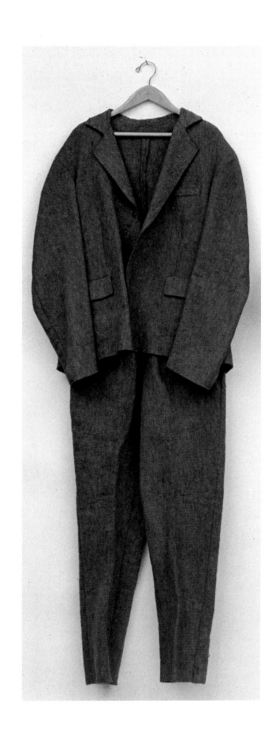

Sarah Charlesworth

Figure, 1983

From the series, *Objects of Desire*

Cibachrome print with lacquered frame

40 × 30 inches

Codes of dress and body language carry with them complex, and all too often oppressive, standards or expectations of desirability or sexuality. By working with an array of iconic-type images, stripping away the particularity of the specific person or model, I attempted to isolate the codes themselves.... All embody assumptions and values whose import extends beyond the language of dress to the underlying human attitudes and relations they bespeak. It is these attitudes and the public codes through which they are reinforced that this work attempts to throw into question.

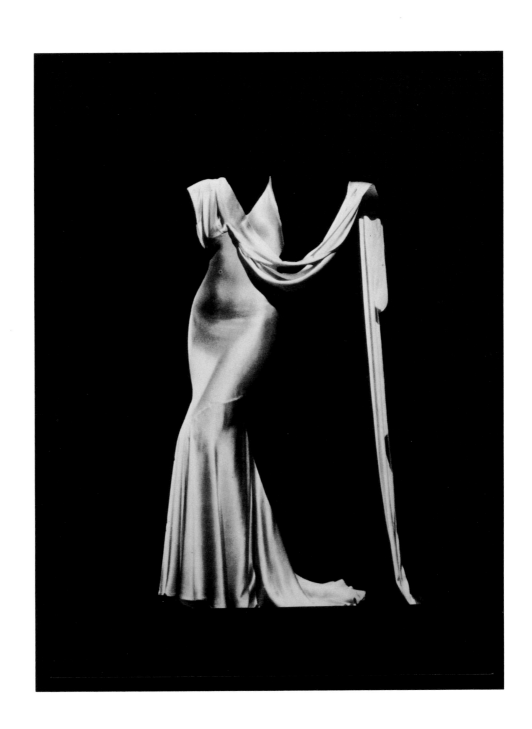

MAUREEN CONNOR

No Way Out, 1990

Steel, body suit, and rubber straps

24 × 80 × 24 inches

When clothes are presented for and as themselves and not part of a particular person's masquerade they begin to expose their artifice. Our imaginations can then explore the potential of the garments—who would wear them, under what circumstances, as well as who would not or should not be permitted to wear them and why. Empty, disembodied, or discarded clothes can generate narratives from the viewers' experiences which allow us to invest them with complex emotional responses.

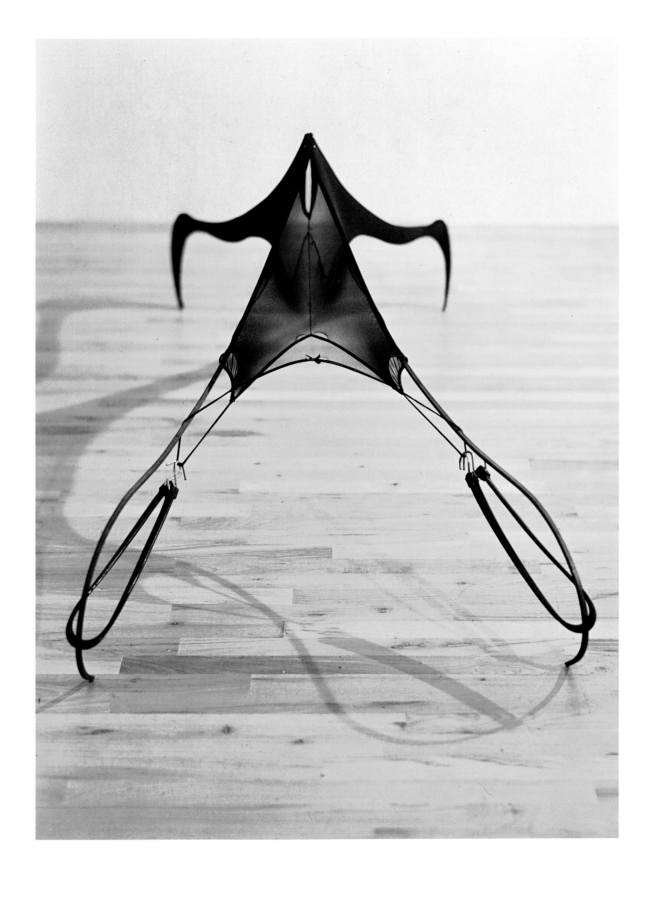

NANCY DAVIDSON

Between Clothing and Nudity, 1991

Mixed media

113 × 48 × 8 inches

It has to do with the construction of the self. Does "being" reduce to a play of appearances? Masquerade is one kind of appearance. A strategy of masquerade; choosing to disguise; to be worn or removed. Does it cover feminine desire or is it an exclusionary practice of the feminine gendered position? Who is observing? What is being observed? Readings that flaunt femininity can conceal aggression. Dissimulation is an alternative reading of fabrication.

The installation sculpture titled *Between Clothing and Nudity* locates the site of a feminized body between a theater and a catalogue. Working with traces, scrims, and diverse light sources the practice of naming and indexing are enticed.

Hovering on the wall, *Things That She Has Touched* refers to classic moments in film history; surrounded by "Marilyn's" skirt blowing up and the nightgown falling down. Through the fabric's color and texture, suggestions of intimate garments and flesh draw out something hidden, latent, and reserved.

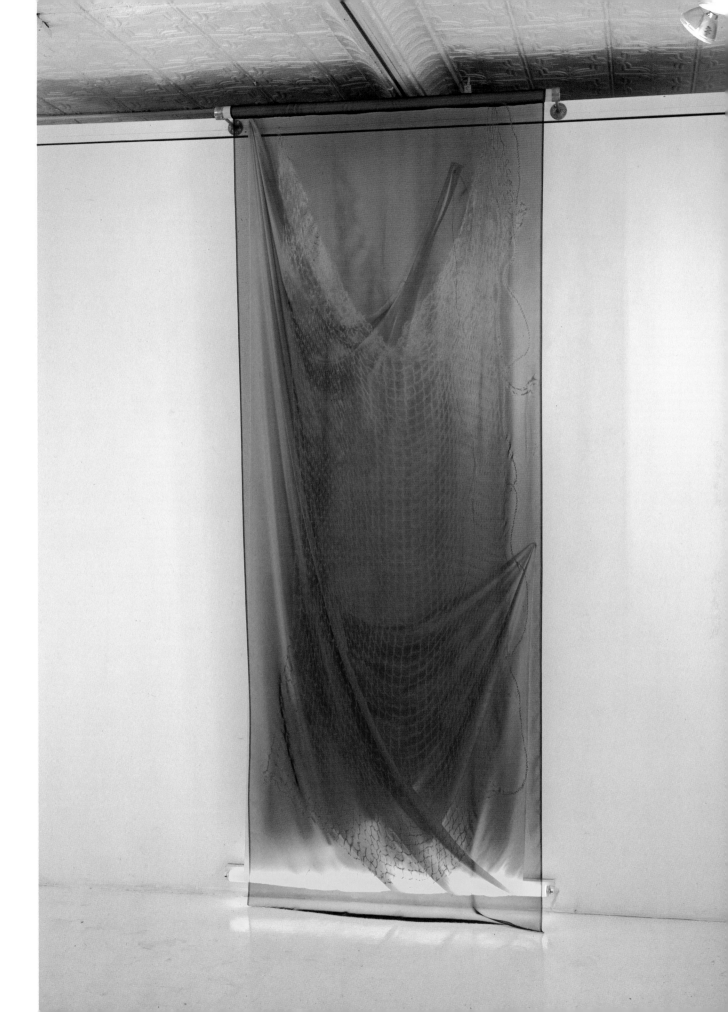

LESLEY DILL

White Hinged Poem Dress, 1992

Mixed media

Dimensions variable

Sometimes I feel skinless. And I go looking for a covering. For me, words are an intervening armor between ourselves and the world. I'm particularly drawn to using the words of Emily Dickinson in my work for their embodiment of psychological states of despair and euphoria. How right to slip inside words, the meaning and shape of some emotion you're feeling, and go out into life. To look inside your closet and find the proper fit—in size, attitude, coherence—and coat your vulnerability with a shell of surrogacy.

In each of the sculptures, the poem is knitted into the emotional metaphor of their being. The *White Hinged Poem Dress* is made so the poem can only be read if the dress is open. When closed, the reading of the poem is illegible. I try to represent the self-conscious sensibilities of the absent head in the act of reading the words. And the hollowness of the indicated but absent body is similar to the earthly borrowing of corporeality by our souls. Perhaps in this era of AIDS and a shrinking world, an empty, not brimful, dress best represents our sense of presence and absence existing concurrently. Similarly, the time of past and future are present at once. Is this dress the memory remnant of someone from the past? Or is it poised, waiting for the Cinderella—or Medea—of the future to slip into its perfect fit?

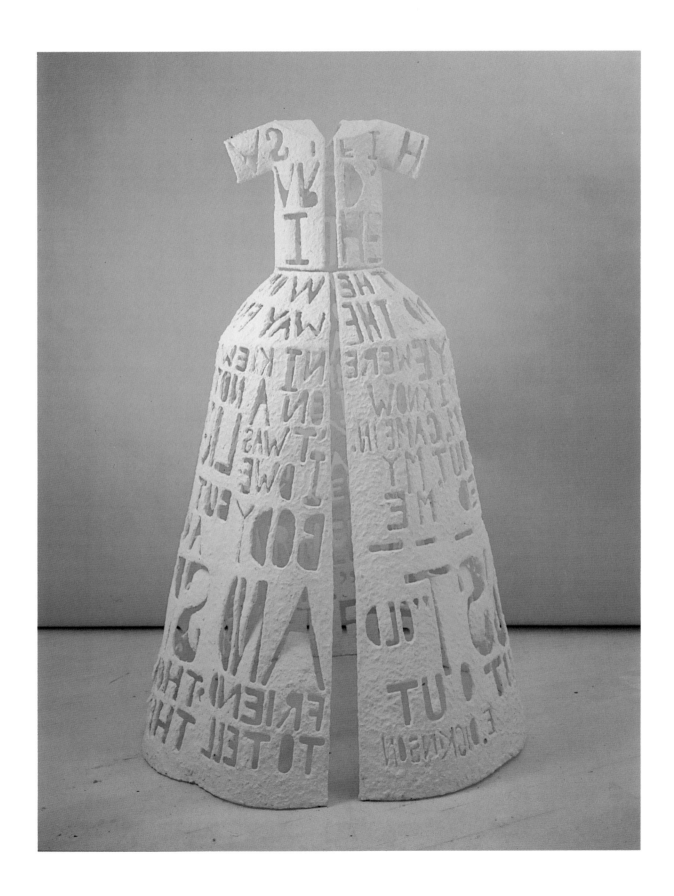

SUZAN ETKIN

DRYCLEAN III, 1990–91

Conveyor belt, fabric, and wire hangers

75 × 95 × 64 inches

DRYCLEAN contains many opposites: the heaviness of the machine and the lightness of the material, the masculinity of the machine and femininity of the clothes, transparency and opacity, circularity and centeredness, movement and stillness, humor and poignancy, rigor and effortlessness; impersonal and yet intimate. The in-between is the shadow, dancing on the floor and walls. When the machine stops and the clothes flutter in movement before the stillness, this provides the counterpoint.

DRYCLEAN is a continuous promenade, it only stops for breath.

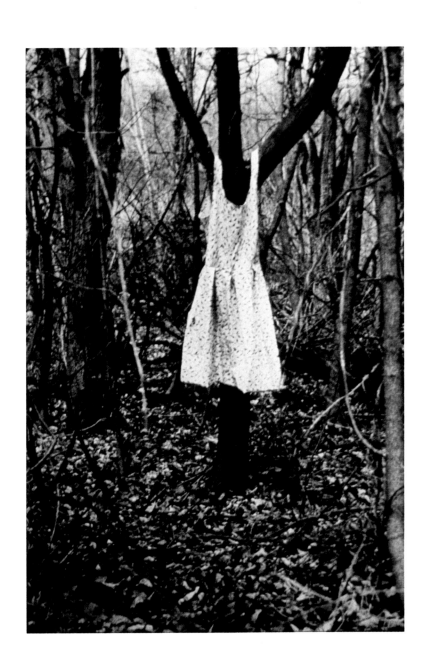

GOTSCHO

Wedding, 1992

Nylon, acetate, and wool

72 × 48 inches

The wedding dress and the wedding costume of the piece called *Wedding*, as the seven men's jackets of the piece *Untitled*, are clothes made in series.... I mean to unpick the lining of the jackets for *Untitled*, to sew the male costume to the female dress for *Wedding*. This is the way *Wedding* has been realized, with male and female costumes hand-sewn face-to-face together by the *ouvertures* normally used by the body to slip on clothes. Here…the body is absent, even in the desire of another body. *Wedding* is part of a series of pieces…about the 'transit zone', the passing of [one] body to another, pieces hand-sewn face-to-face together by the *ouvertures* as I said before.... I would prefer not to explain more.

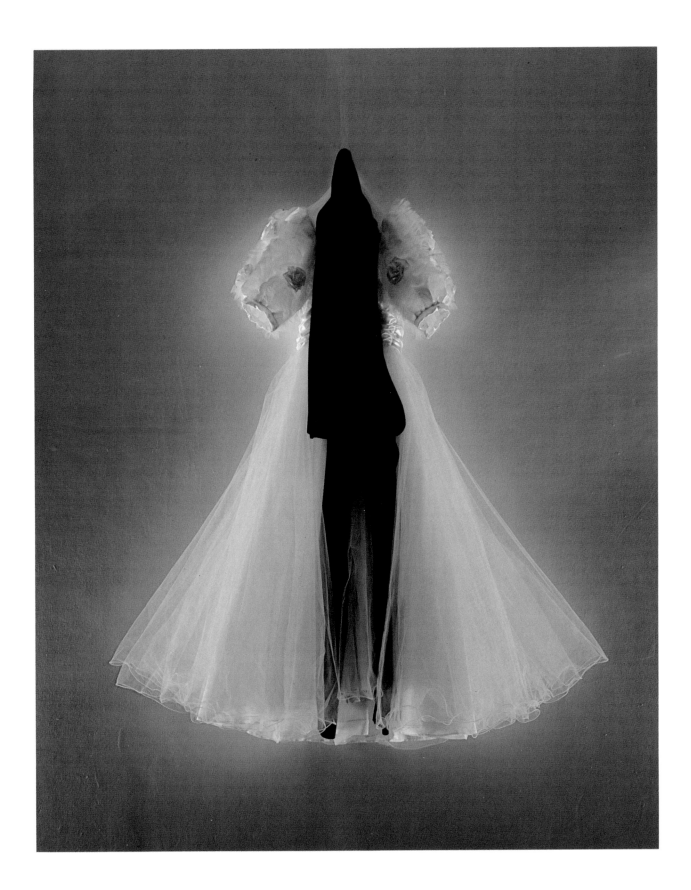

KATHY GROVE

The Other Series: After Man Ray, 1992

Gelatin silver print

9 × 7 inches

Familiarity breeds contempt. It also dulls the senses. Using the device of the "empty dress" forces the viewer to examine more closely and critically the image with which they had thought they were so familiar. It creates a red flag—a piece of evidence which compels them to become a detective and therefore an active participant in the creation of meaning and completion of the narrative. The "empty dress" signals the presence of absence —that of the erased woman. The images I choose to alter are regarded as masterpieces of western culture. They form a kind of collective cultural unconscious and thus they depict a history of events, relationships, and power structures that have been thought of as "natural" throughout the ages.

The artificiality of the "empty dress" is a clue which obliges the viewer to observe, not just look, and to rethink the shifting nature of truth, memory, and power.

OLIVER HERRING

Untitled, 1993

From the series, *A Flower for Ethyl Eichelberger* (An Ongoing Project)

Hand-knit Mylar

2 parts, dimensions variable

The performance artist and drag queen Ethyl Eichelberger used clothes to transform himself as well as traditional notions of gender and sexuality. During his performances clothing enabled him to flip-flop between male and female stereotypes until, in the end, those clothes and stereotypes became so transparent that what emerged was only Ethyl the individual. Ethyl Eichelberger wore the Emperor's clothes in reverse.

My ongoing project, *A Flower for Ethyl Eichelberger*, was inspired by Ethyl's suicide due to his HIV infection. Although the project is a personal meditation on the death of someone I admired, by continuously adding pieces over time that meaning is transformed into a metaphor for AIDS in general. And since each piece is made through the cumulative process of knitting, every stitch is (like the overall project) both a measure of commitment and time. Ethyl Eichelberger used clothes as a personal form of activism. For me knitting clothes means the same.

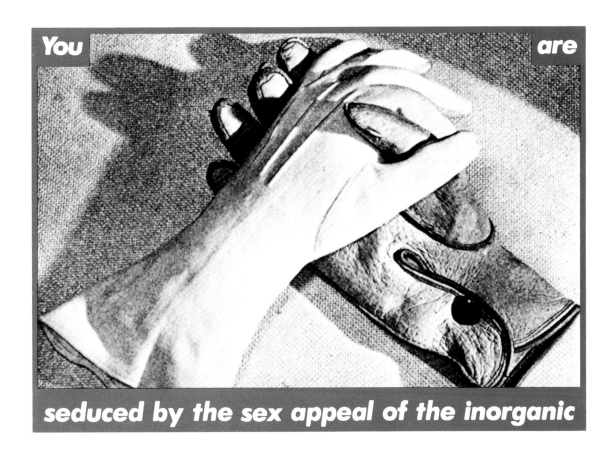

ANNETTE MESSAGER

Histoire des Petites Effigies, 1990

Mixed-media installation

Dimensions variable

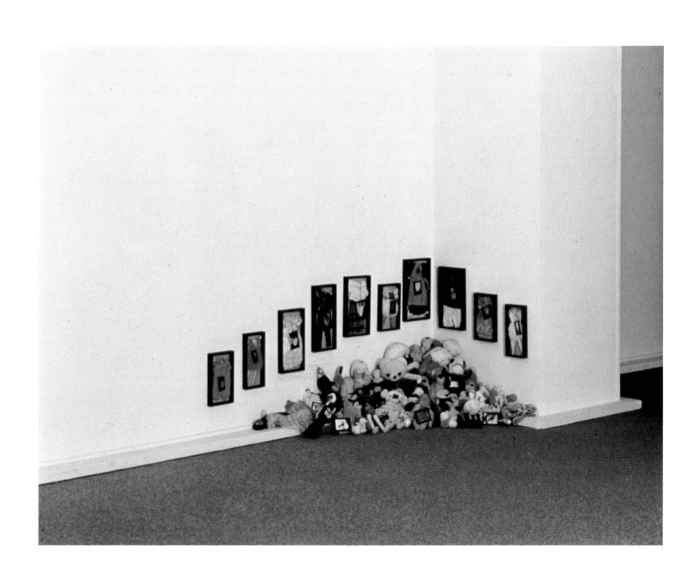

Tony Oursler with
Constance DeJong

Sex Plotter, 1992

Mixed-media installation

Dimensions variable

ZIZI RAYMOND

Untitled, 1992

Mixed media

$21\frac{1}{2} \times 118 \times 28$ inches

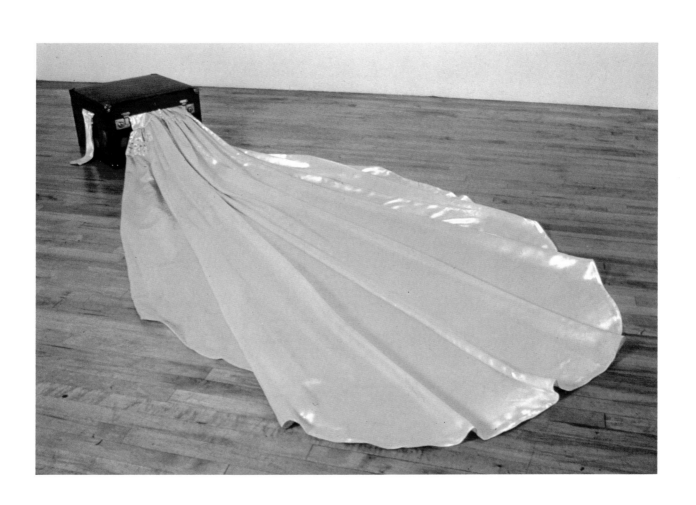

ELAINE REICHEK

Grey Man, 1989

Mixed-media installation

2 of 5 parts, approximately 65 × 71 inches overall

I don't start with clothes, I start with nakedness. The photographs I use in the *Tierra del Fuego* series show Fuegian Indians of the early 20th century. These men had no clothes, and didn't need them, despite their Antarctic climate—they greased their bodies against the wind, and a diet with plenty of fat helped keep them insulated. What they wore, for reasons of their own, was body paint. I knit their skins.

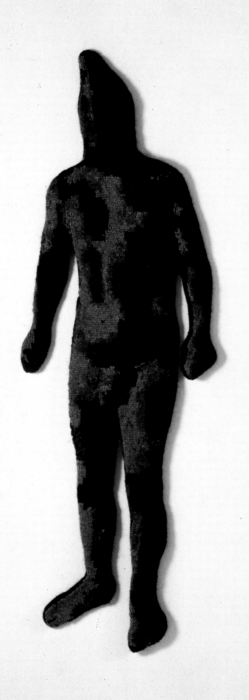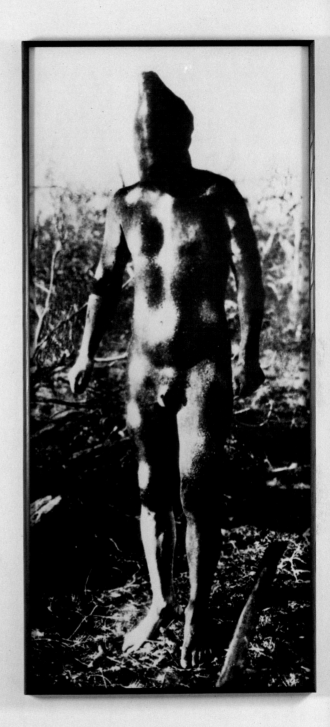

RUTH SCHEUING

13 Men or Penelope II (detail), 1989

Installation, 13 mens' jackets, plastic hangers, and metal hooks

36 × 24 × 3 inches each

36 × 312 × 3 inches overall

Clothing is a codified system for communication within a structured social space. Clothing defines/expresses the identity of the body both to its wearer and to the observer. Because of its proximity to the body, clothing can get conflated with it as a second skin.

History and current social customs have affected how we interpret representation of the naked body in relationship to the actual body. Clothing deals effectively with the intimate and private, speaking directly of the way we hide underneath these layers of fabric. By focusing on the apparent irrelevant (clothing), the relevant (body) is able to relax, able to reveal itself, to understand its own process of construction (identity).

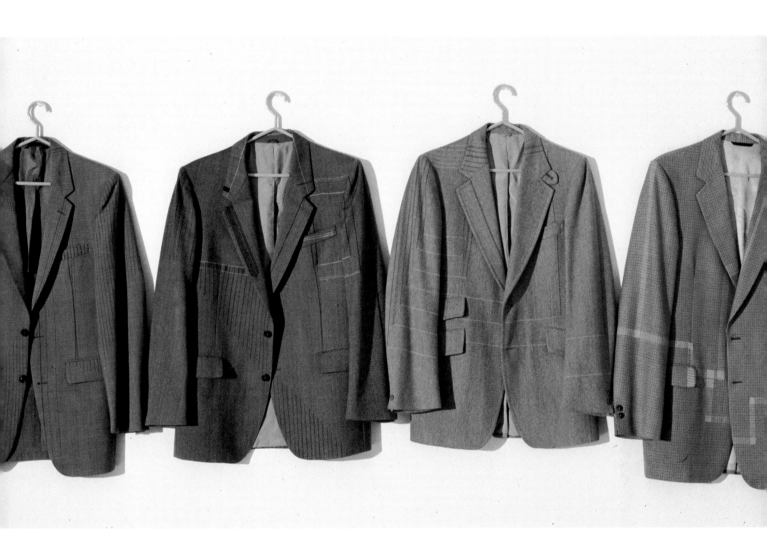

STEPHEN SCHOFIELD

Hung Pocket, 1990

Rubber gloves and plaster

16 × 8 × 11 inches

I've often asked myself where the outside ends and the inside begins.... With this ensemble of rubber glove pieces I wanted to consider a simple and provocative strategy by turning inside out, doubling, involuting the gloves. As Michel Serres notes in *Distraction*, as soon as one works on and opens up the inside of matter it, the inside, turns into the outside. Traditionally the glove has signified a phallus by both the form of its digits and by its association with the exercise of power, an iron fist in a velvet glove being just one example. The interventions in these pieces are playful and gentle, poking the rubber fingers back on themselves or over another, so while the power reference has been overturned effectively it has also been done quietly.

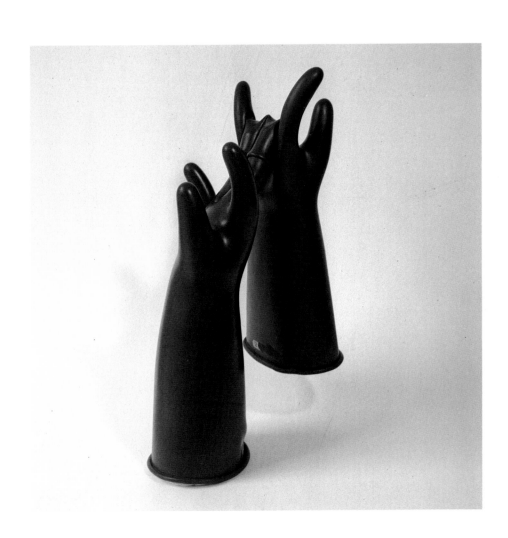

BEVERLY SEMMES

Watercoats, 1991

Fabric, wood, and metal hangers

Dimensions variable

Watercoats is about a landscape—a waterfall
where two people become water. It is about
conflicting internal voices: one personality
pulled between two heads and a body.

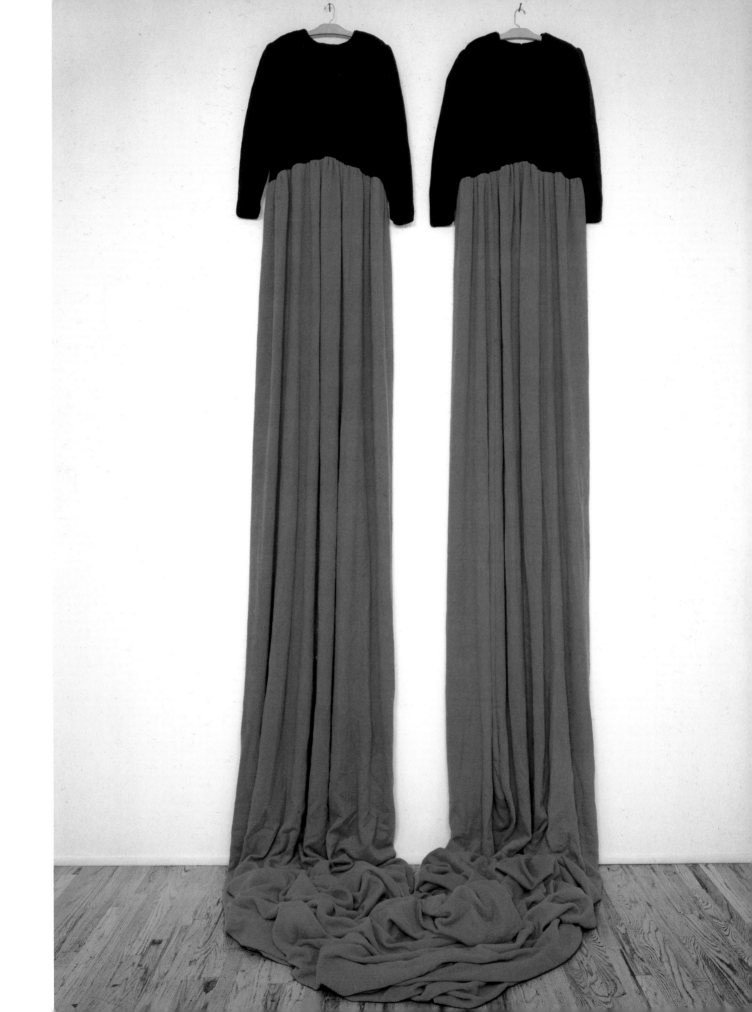

JUDITH SHEA

Crawl, 1983

Bronze

6 × 22 × 11½ inches

In meeting other working artists, seeing and understanding their work and ideas, I found center. I began to view art as home for overgrown and orphaned knowledge from other disciplines, art out of architecture, anthropology, philosophy, and to understand context as opposed to displacement though works like Scott Burton's "furniture," Robert Kushner's "fashion shows," or Judy Pfaff's environments. That was the initial impact, and later I began to plumb the work more intensely for its figural presence—using dress and coat as icon and prototype; shirt and pants as a residual of civilization, of time, of presence; and fragments of clothing as a metaphor for experience, an expression of an emotional state.

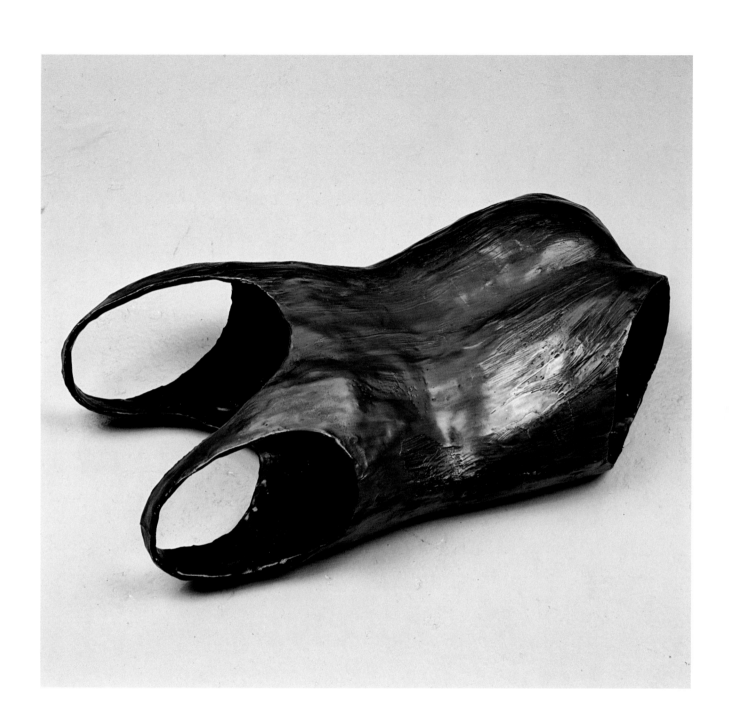

CINDY SHERMAN

Untitled, 1987

Chromogenic color (Ektacolor) print

85 × 60 inches

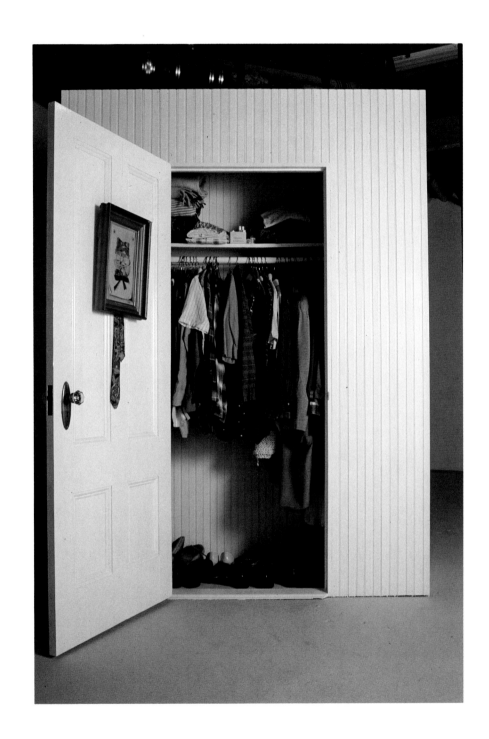

MILLIE WILSON

Trousers (for Tony), 1992

Mixed-media installation

Dimensions variable

As to the increasing prevalence of artists (myself includ-
ed) using clothing abstracted from the body, I would
speculate that this could, in part, be a strategy for avoid-
ing literal, illustrative readings, a revived interest in sur-
realism, and the influence of fashion layouts in print
media. In *Trousers (for Tony)*, I attempt to produce a prob-
lematized intersection of class, gender, and sexuality, a
"she" who resists the feminine fashion commodity by
reinventing herself as a thrift-store dandy. Using actual
clothing and/or body would have reified a set of readings
at the expense of other possibilities.

Her best friend died in the autumn. A few weeks later a thrift
store run by an AIDS service organization opened in her neighborhood.
She began to go there, sometimes as often as once a day, to check
the racks of men's clothing. She had worn secondhand clothes for
almost as long as she could remember. By ragpicking patiently and
obsessively, she had eventually achieved the look of a privileged
dandy.

The new store offered an unusual number of beautifully tailored
jackets, shirts and trousers, and gradually it became the source
of her entire wardrobe. Sometimes it seemed that the secrets
and desires of her own body could be revealed in these acts of
recuperation. At some point she realized that her shopping was
an archaeology of thousands of lost lives. Like the chatty obituaries
in gay newspapers, never had the details of gay men's lives been so
carefully recorded. The more they vanished, the more they were
represented. Her costumes, she came to understand, were evidence
that what remained of beloved friends were garments scattered
across the city, and beyond.

indescribables

ineffables

inexplicables

inexpressibles

innominables

unhintables

unmentionables

unspeakables

unutterables

CHECKLIST

Height precedes width precedes depth

POLLY APFELBAUM

Born: 1955, Abington, Pennsylvania
Resides: New York, New York

Two Spanish Ladies Under a Gypsy Moon, 1990
2 felt hats on 2 metal chairs with vinyl seats
35 × 15 × 17 inches each
Courtesy the artist

Drown the Clown, 1990
Cotton clown suits and fresh flowers
78 × 103 × 3 inches overall
Courtesy the artist

JOSEPH BEUYS

Born: 1921, Kleve, Germany
Died: 1986

Felt Suit, 1970
Felt with wooden hanger
72 × 28 inches
Collection the Chase Manhattan Bank, N.A.

SARAH CHARLESWORTH

Born: 1944, East Orange, New Jersey
Resides: New York, New York

Figure, 1983
From the series, *Objects of Desire*
Cibachrome print with lacquered frame
40 × 30 inches
Courtesy the artist and
Jay Gorney Modern Art, New York

MAUREEN CONNOR

Born: Baltimore, Maryland
Resides: New York, New York

The Bride Re-Dressed, 1989
Steel and lace
54 × 24 × 34 inches
Courtesy the artist and
Germans van Eck Gallery, New York

No Way Out, 1990
Steel, body suit, and rubber straps
24 × 80 × 24 inches
Courtesy the artist and
Germans van Eck Gallery, New York

NANCY DAVIDSON

Born: 1943, Chicago, Illinois
Resides: New York, New York

Between Clothing and Nudity, 1991
Mixed media
113 × 48 × 8 inches
Courtesy the artist and
Richard Anderson Gallery, New York

Things That She Has Touched, 1991
Cloth and wire
72 × 50 × 36 inches
Courtesy the artist and
Richard Anderson Gallery, New York

LESLEY DILL

Born: 1950, Bronxville, New York
Resides: New York, New York

Poem Dress of Circulation, 1993
Charcoal and ink on rice paper
45 × 39 × 4 inches
Courtesy the artist

White Hinged Poem Dress, 1992
Mixed media
Dimensions variable
Courtesy the artist

SUZAN ETKIN

Born: 1955, New York, New York
Resides: New York, New York

DRYCLEAN III, 1990–91
Conveyor belt, fabric, and wire hangers
75 × 95 × 64 inches
Courtesy the artist and
Paul Kasmin Gallery, New York

STEVEN EVANS

Born: 1964, Key West, Florida
Resides: New York, New York

The Turn of the Screw, 1990–92
Mixed-media installation
Dimensions variable
Courtesy the artist

Evidence of a Subliminal World, 1992
Sewn wool and cotton on
antique horse and carriage
55 × 24 × 64 inches
Courtesy the artist

LESLIE FRY

Born: 1954, Montreal, Quebec, Canada
Resides: Winooski, Vermont

Imago, 1992
Doll's dress, polyester, and boning
28 × 7 × 7 inches
Courtesy the artist

Fit, 1992
Chiffon and a zipper
25 × 7 × 3 inches
Courtesy the artist

Lips Speaking Together, 1992
Chiffon and a button
12 × 9 × 5 inches
Courtesy the artist

ROBERT GOBER AND CHRISTOPHER WOOL

Robert Gober
Born: 1954, Wallingford, Connecticut
Resides: New York, New York

Christopher Wool
Born: 1955, Chicago, Illinois
Resides: New York, New York

Untitled, 1988
Gelatin silver print
14 × 11 inches
Courtesy the artists and
Paula Cooper Gallery, New York

GOTSCHO

Born: 1945, Le Puy en Velay, France
Resides: Paris, France

Wedding, 1992
Nylon, acetate, and wool
72 × 48 inches
Courtesy the artist and
Galerie Urbi et Orbi, Paris

Untitled, 1992
Wool and acetate
72 × 120 inches
Courtesy the artist and
Galerie Urbi et Orbi, Paris

KATHY GROVE

Born: 1948, Pittsburgh, Pennsylvania
Resides: New York, New York

The Other Series: After Muybridge, 1991
Gelatin silver print
12 ½ × 22 ½ inches
Courtesy the artist and P.P.O.W., New York

The Other Series: After Man Ray, 1992
Gelatin silver print
9 × 7 inches
Courtesy the artist and P.P.O.W., New York

OLIVER HERRING

Born: 1964, Heidelberg, Germany
Resides: Brooklyn, New York

Untitled, 1993
From the series, *A Flower for Ethyl Eichelberger*
(An Ongoing Project)
Hand-knit Mylar
2 parts, dimensions variable
Courtesy the artist

MARY KELLY

Born: 1941, Minnesota
Resides: New York, New York

Supplication, 1985
From the series, *Interim, Part I: Corpus*, 1984–85
Laminated photo-positive, silkscreen, and
acrylic on plexiglas
6 panels, 48 × 36 inches each
Courtesy the artist and
Postmasters Gallery, New York

BARBARA KRUGER

Born: 1945, Newark, New Jersey
Resides: New York, New York

Untitled, 1982
Postcard
4 ¼ × 6 inches
Courtesy the artist

ANNETTE MESSAGER

Born: 1943, Berck-sur-Mer, France
Resides: Paris, France

Histoire des Petites Effigies, 1990
Mixed-media installation
Dimensions variable
Courtesy the artist,
Josh Baer Gallery, New York, and
Galerie Crousel-Robelin, Paris

Histoire des Robes, 1990
Mixed media
2 parts, 51 ⅛ × 11 ¾ × 4 ¾ inches overall
Private collection

TONY OURSLER WITH CONSTANCE DEJONG

Tony Oursler
Born: 1957, New York, New York
Resides: New York, New York and
Boston, Massachusetts

Constance DeJong
Born: 1946, Canton, Ohio
Resides: Nyack, New York

Sex Plotter, 1992
Mixed-media installation
Dimensions variable
Courtesy the artists

ZIZI RAYMOND

Born: 1960, New York, New York
Resides: Crockett, California

Untitled, 1992
Mixed media
21 1/2 × 118 × 28 inches
Collection Barbara and David Hancock

ELAINE REICHEK

Born: New York, New York
Resides: New York, New York

Grey Man, 1989
Mixed-media installation
5 parts, approximately 65 × 71 inches overall
Courtesy the artist and
Michael Klein, Inc., New York

RUTH SCHEUING

Born: 1947, Locarno, Switzerland
Resides: Vancouver, British Columbia, Canada

13 Men or Penelope II, 1989
Installation, 13 mens' jackets, plastic hangers,
and metal hooks
36 × 24 × 3 inches each
36 × 312 × 3 inches overall
Courtesy the artist

STEPHEN SCHOFIELD

Born: 1952, Toronto, Ontario, Canada
Resides: Jersey City, New Jersey

The Envelope Please, 1990
Rubber gloves and copper
4 × 6 × 16 inches
Courtesy the artist and
Horodner Romley Gallery, New York

Hung Pocket, 1990
Rubber gloves and plaster
16 × 8 × 11 inches
Courtesy the artist and
Horodner Romley Gallery, New York

BEVERLY SEMMES

Born: Washington, D.C.
Resides: New York, New York

Watercoats, 1991
Fabric, wood, and metal hangers
Dimensions variable
Private collection

JUDITH SHEA

Born: 1948, Philadelphia, Pennsylvania
Resides: Housatonic, Massachusetts and
New York, New York

3 Square Shirts, 1977
Silkscreened cotton and wooden dowel
3 parts, 22 1/2 × 36 × 1/2 inches each
Courtesy the artist

Crusader, 1982
Cast iron
2 parts, 21 × 15 1/2 × 5 inches overall
Collection Nancy and Steven Oliver

Crawl, 1983
Bronze
6 × 22 × 11 1/2 inches
Collection The Edward R. Broida Trust

CINDY SHERMAN

Born: 1954, Glenridge, New Jersey
Resides: New York, New York

Untitled, 1987
Chromogenic color (Ektacolor) print
85 × 60 inches
Collection Eli Broad Family Foundation

ELISE SIEGEL

Born: 1952, Newark, New Jersey
Resides: New York, New York

Portraits #1– #5, 1992
Wire mesh and acrylic modeling paste
5 parts, 15 × 14 × 7 inches each
15 × 190 × 7 inches overall
Courtesy the artist

CLAUDE SIMARD

Born: 1956, Larouche, Quebec, Canada
Resides: New York, New York

Aide de Memoire, 1990
Mixed-media installation
96 × 60 × 30 inches
Courtesy the artist and
Jack Shainman, New York

MILLIE WILSON

Born: 1948, Hot Springs, Arkansas
Resides: Los Angeles, California

Odd Glove, 1990
Mixed-media installation
30 1/2 × 34 × 30 inches
Collection Eileen and Peter Norton

Trousers (for Tony), 1992
Mixed-media installation
Dimensions variable
Courtesy the artist and
Ruth Bloom Gallery, Santa Monica

© 1993 Independent Curators Incorporated
799 Broadway, Suite 205
New York, NY 10003
(212) 254-8200; fax (212) 477-4781

Editorial consultant: Marybeth Sollins
Design and typography: Russell Hassell
Lithography: The Studley Press
Edition of 2500
Library of Congress Catalogue Card Number: 93–78115

ISBN: 0–916365–39–5